First published 2014 by Modern Toss Ltd.
Modern Toss, PO Box 386, Brighton BN1 3SN, England
www.moderntoss.com

ISBN 978-0-9929107-0-9

The Desperate Business cartoons first appeared in Private Eye

Text and illustrations copyright © Modern Toss Limited, 2014
PO Box 386, Brighton BN1 3SN, England

The right of Jon Link and Mick Bunnage to be identified as the
authors of this work has been asserted by them in accordance
with the Copyright, Designs and Patents Act 1988.

A CIP catalogue record for this book is available from the British Library.

Designed and typeset by Modern Toss
Printed and bound by Proost Belgium

Visit www.moderntoss.com to read more about all our books and to buy them yeah.
You will also find lots of other shit there, and you can sign up to our mailing list so
that you're always kept bang up to date with it, cheers.

MODERN TOSS PRESENTS

Work

by Jon Link and Mick Bunnage

work

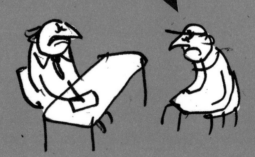

work

I think I'll go home, I'm a bit bored

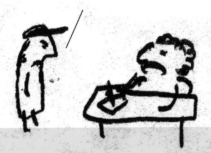

work

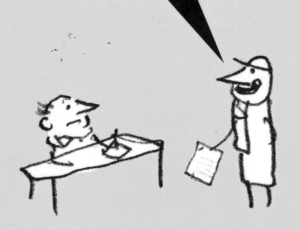

work

so if I keep not coming in, you're going to start not paying me?

interview

work

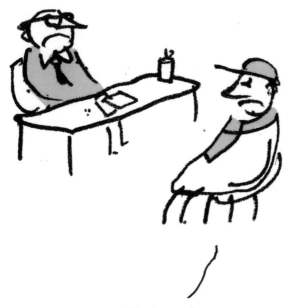

I'm applying to go on The Apprentice next year,
can you give me a reference confirming that I'm capable
of bollocksing up really basic tasks to a very high standard

work

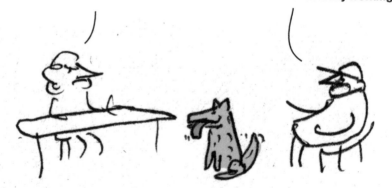

appraisal

work

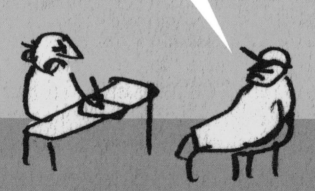

I'm thinking about taking a sabbatical, what is it?

work

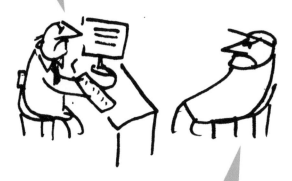

work

key strategy meeting

Sir Paul Pot

CEO & Chairman

long shot

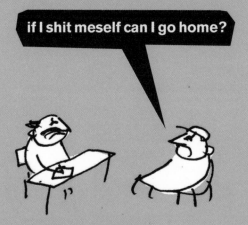

work

work

water cooler moment

work

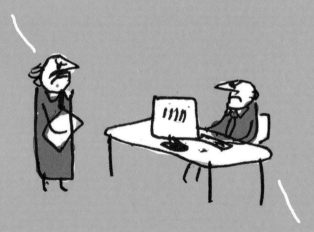

work

work

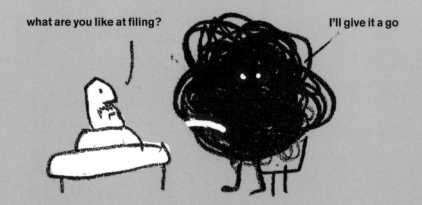

work

I've heard the printer's broken, so I'm not coming in

work

... and furthermore you are by far the worst employee we've ever had

is this a wind up?

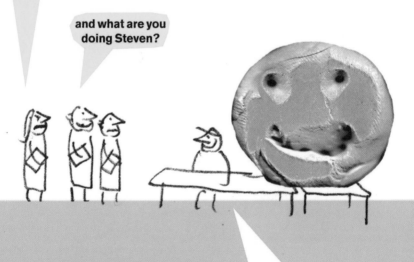

first day job enquiry

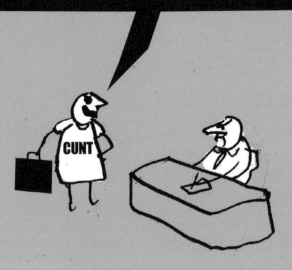

work

work experience

hello are you coming in?

I better check the calendar
I think I'm still on my gap year

work

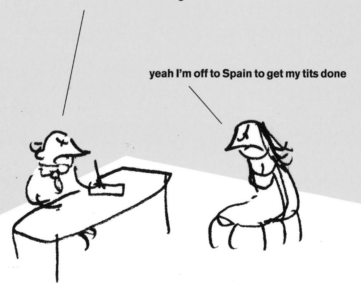

interview

desperate business

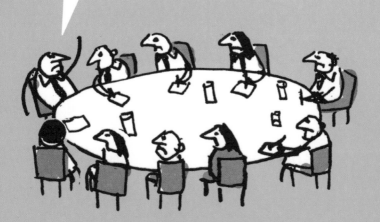

job shadow

I think you're taking this job shadow thing a bit far

I just want you to know I'm giving this 110%

work

yeah it's a bit quiet this morning, I've just been googling my name, 'Steve's' pretty common apparently

work

interview

work

careers advice

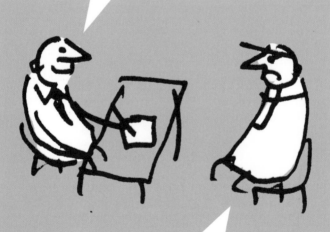

interview

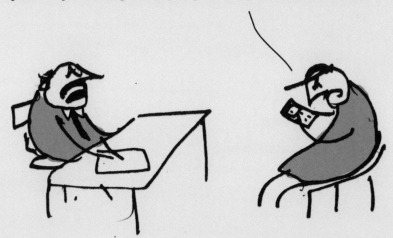

work

maverick boss

work

water cooler moment

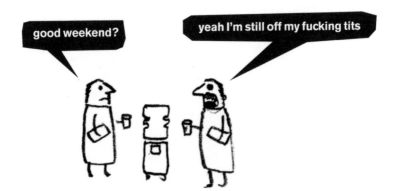

job share

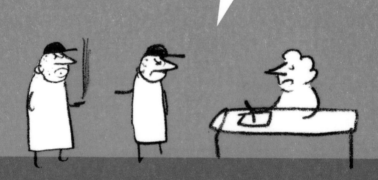

interview

and I see here you went to Cambridge

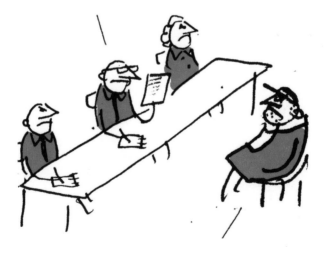

yeah I had to drop something off for someone, I was back by half six

written warning

worth a punt

worth a punt

work

in an ideal world I'd tell you to stick this job up your arse

work

work

work

desperate business

We've decided to have a bit of fun with the old holiday thing this year. First person to ask for one gets the sack.

executive burnout

desperate business

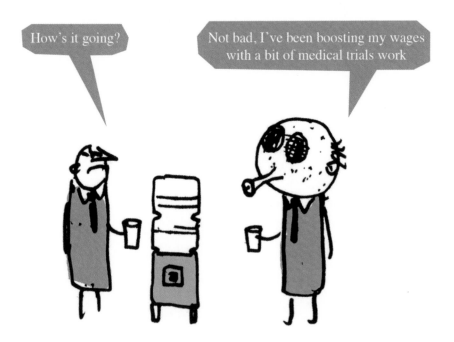

desperate business

we're exploring new business opportunities. Carry on with the accounts but every time that red light goes on slip your top off

work

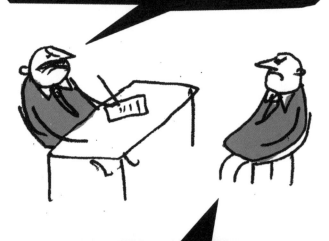

strategy meeting

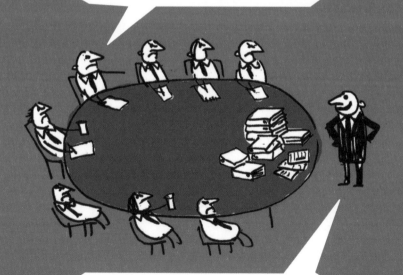

narcissist boss

Anyway, cheers for all your hard work
and here's a little something from me

work

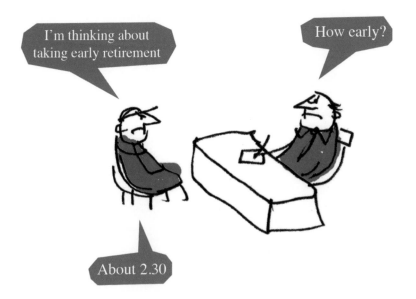

work

we've decided to up your hourly rate by not having you in so much

desperate business

I've got your wages here but I'd like to offer you all
double or nothing on a fist fight in the car park

interview

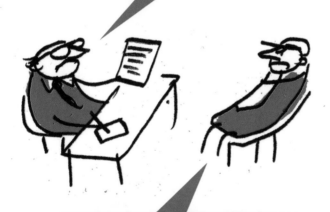

data analyst

work

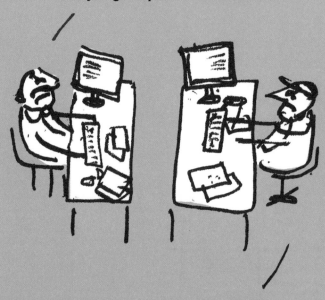

work experience

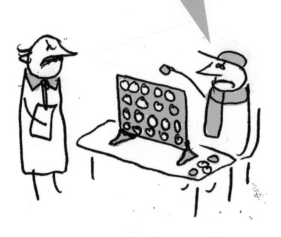